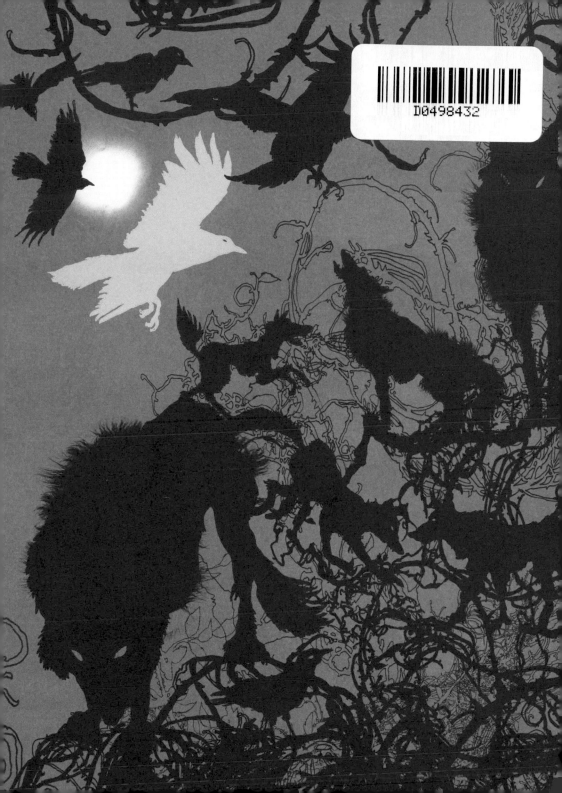

Little RED RIDING Hood

The Brothers Grimm

Illustrations by
Daniel Egnéus

HARPER
DESIGN

An Imprint of HarperCollins Publishers

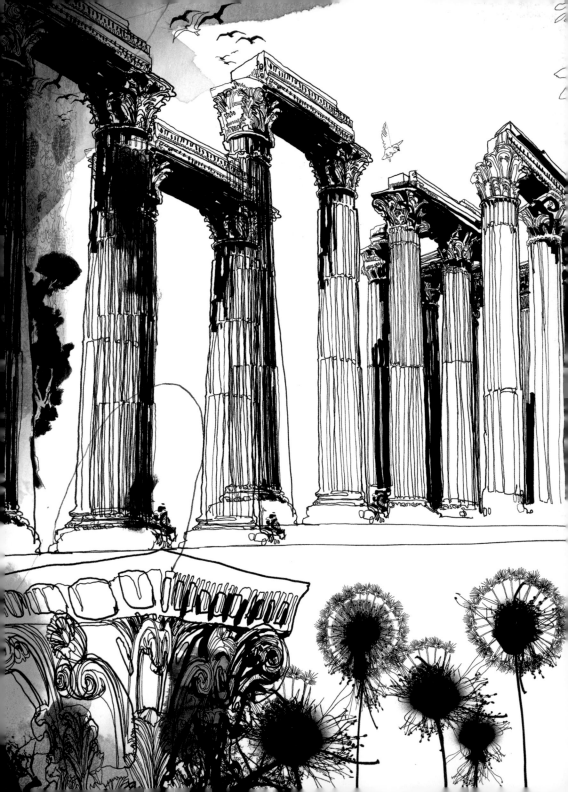

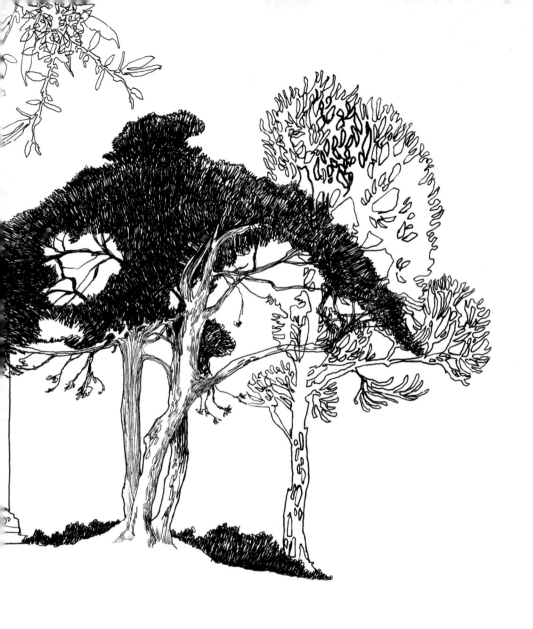

once upon a time...

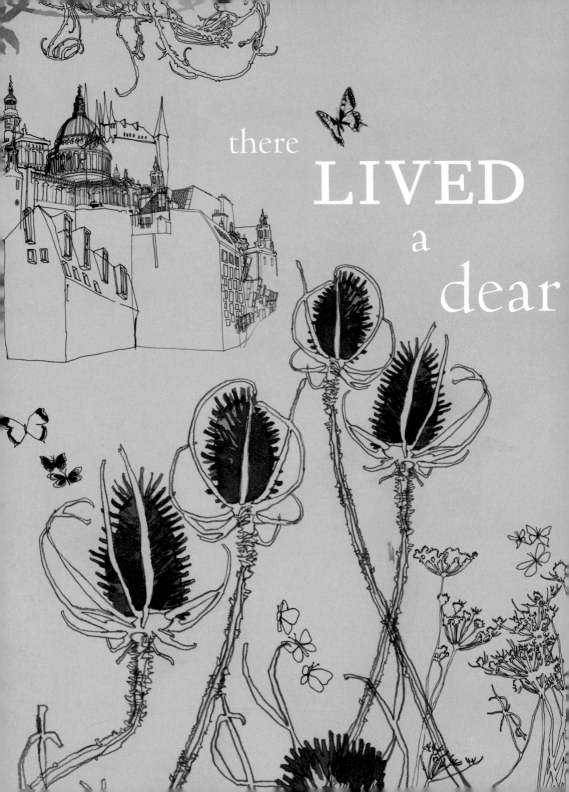

there LIVED a dear

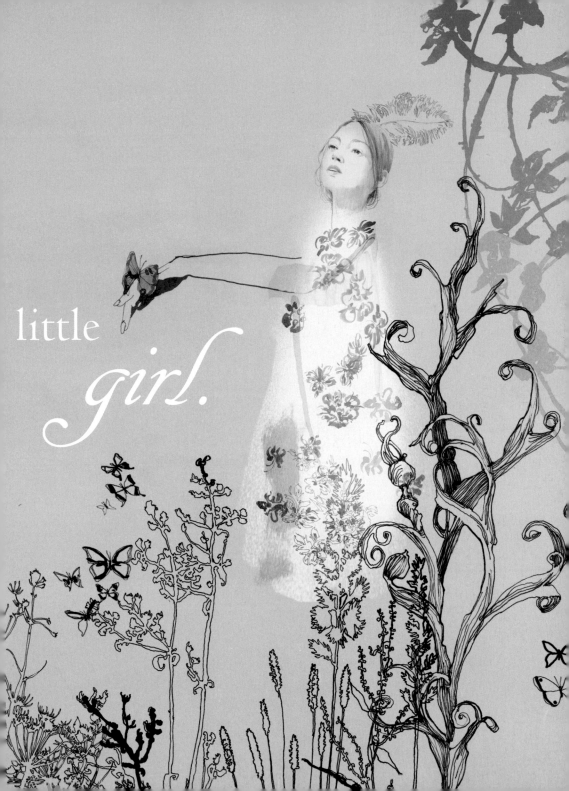

little *girl.*

Everyone who
met her liked her,
but the **PERSON**
who *loved* her
best of all
was her
GRANDMOTHER,

and she was
always *giving* *her*
gifts.

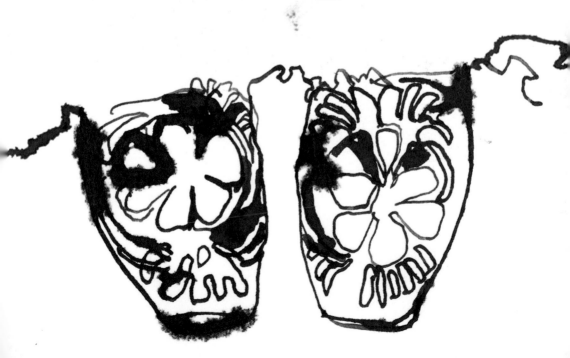

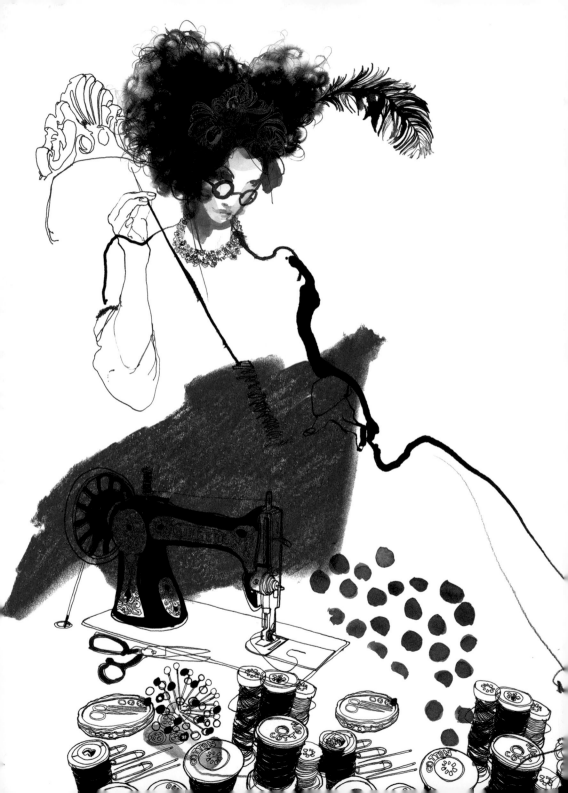

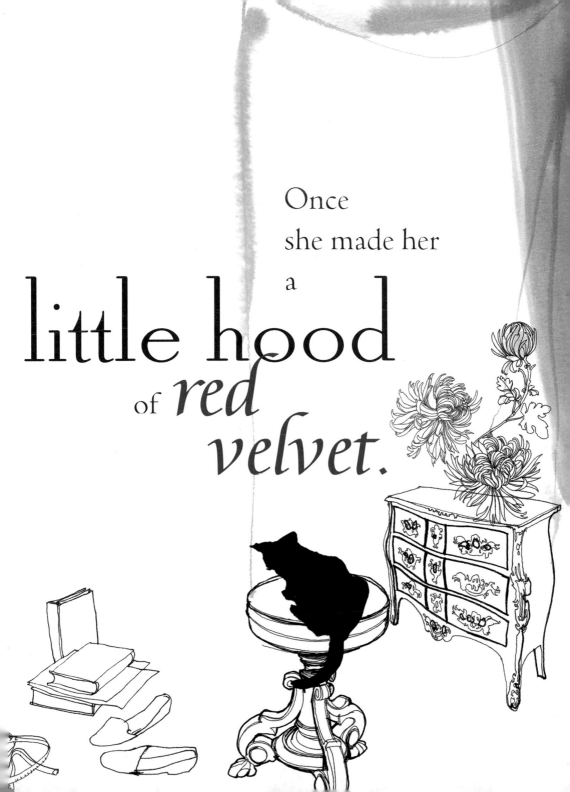

Once
she made her
a
little hood
of *red*
velvet.

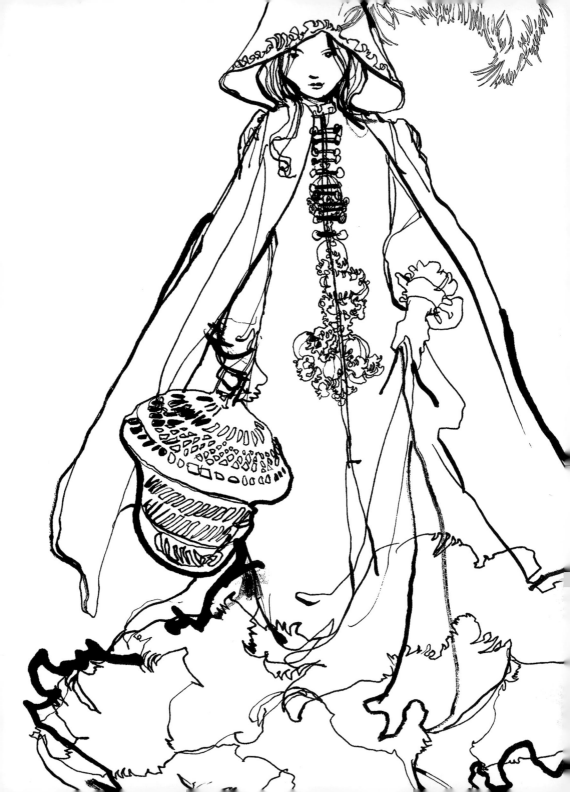

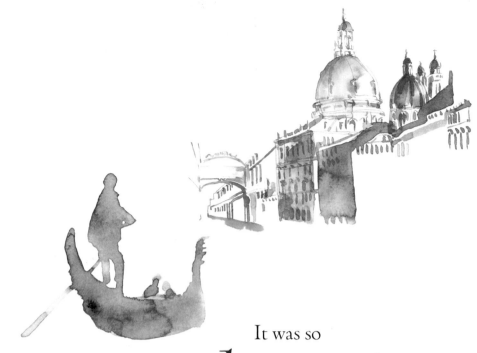

It was so

becoming

to her

that the girl

WANTED TO WEAR IT

all the time,

and so

she came to be

CALLED

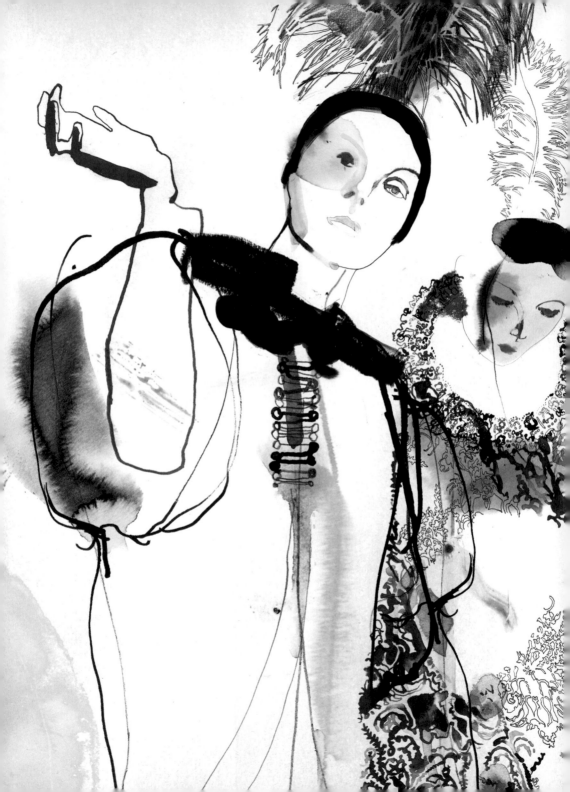

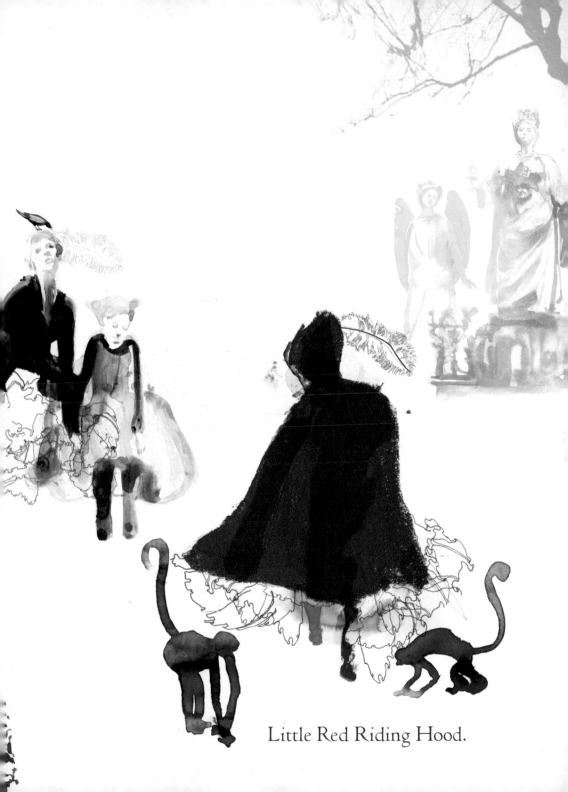

Little Red Riding Hood.

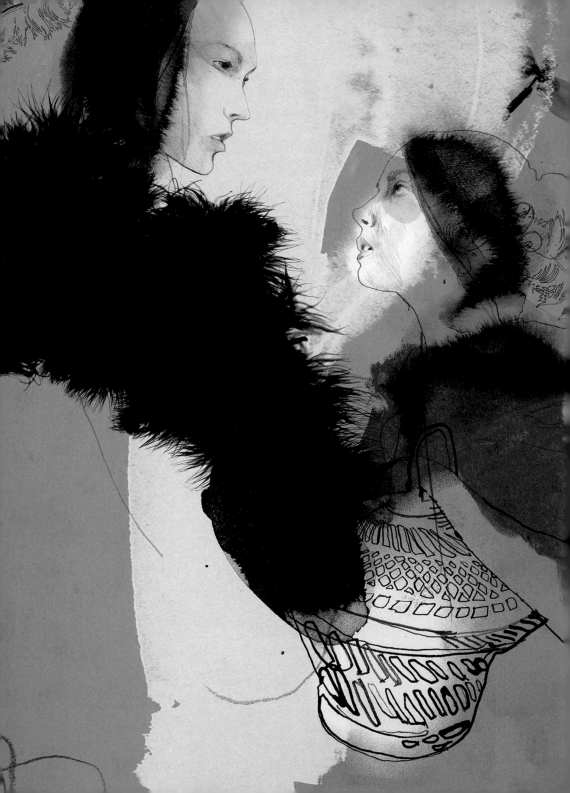

One day
the girl's mother
said to her:

"Little Red Riding Hood,

here are some
cakes
and a
BOTTLE OF WINE.

Take them to your
GRANDMOTHER.

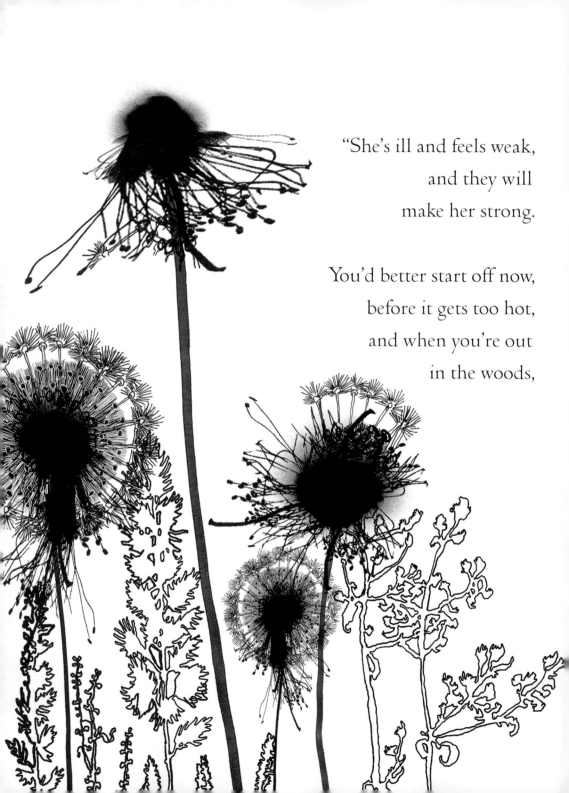

"She's ill and feels weak,
and they will
make her strong.

You'd better start off now,
before it gets too hot,
and when you're out
in the woods,

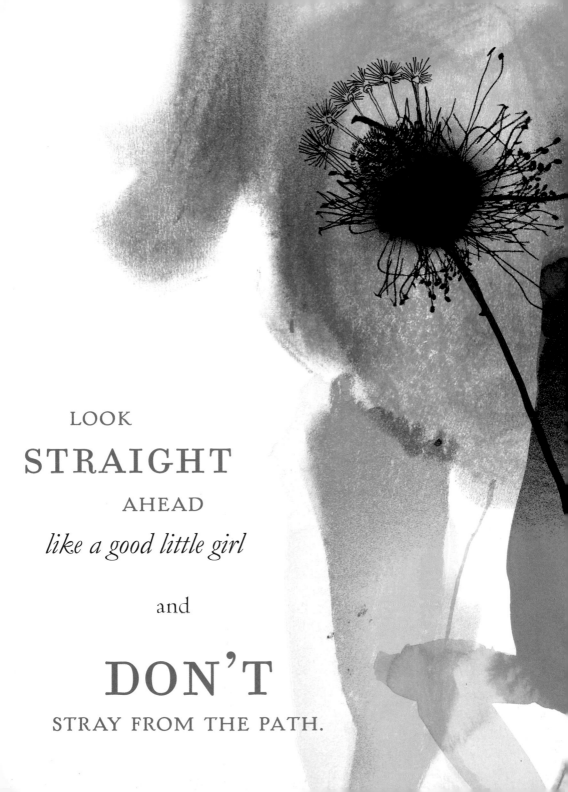

LOOK

STRAIGHT

AHEAD

like a good little girl

and

DON'T

STRAY FROM THE PATH.

"Otherwise *you'll fall* and *break the bottle,* and then there'll be nothing for GRANDMOTHER. And when you walk into her parlor, don't forget to say good morning, and don't go poking around in all corners of her house."

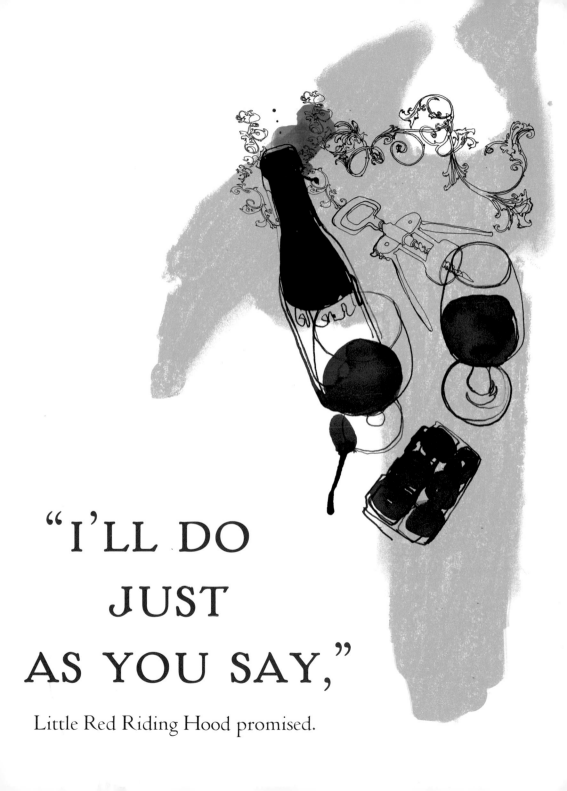

"I'LL DO JUST AS YOU SAY,"

Little Red Riding Hood promised.

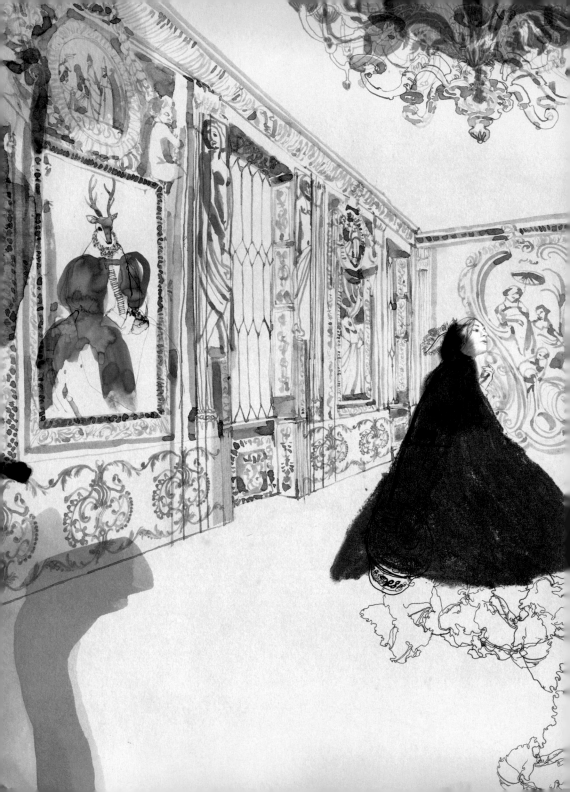

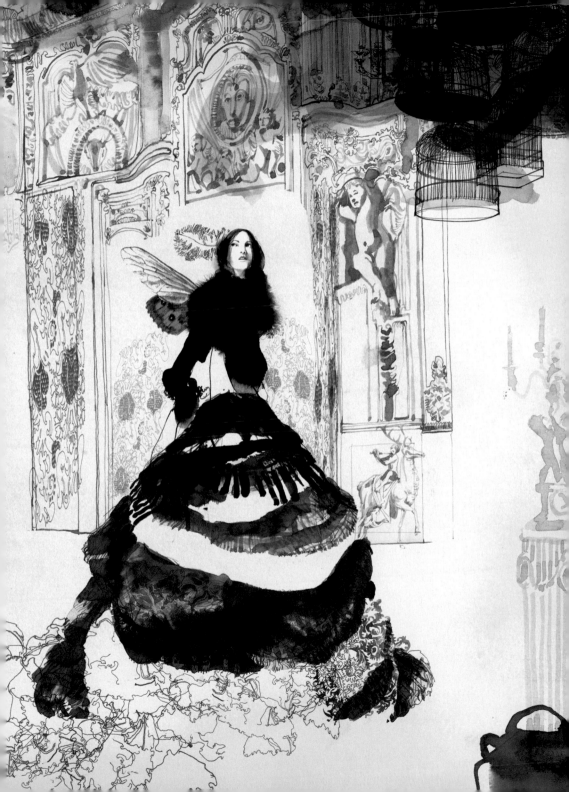

GRANDMOTHER lived deep in the woods, about a half hour's walk from the village. No sooner had LITTLE Red

forest than

set foot in the

HOOD

Riding

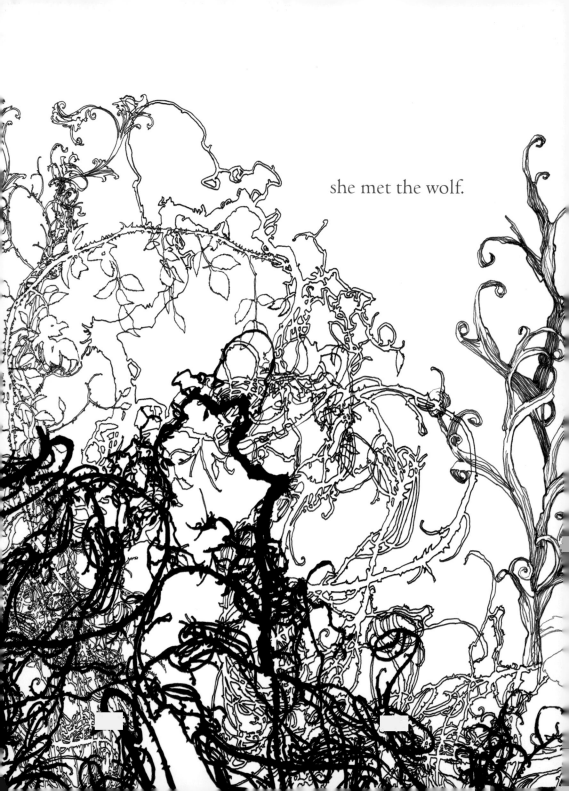

she met the wolf.

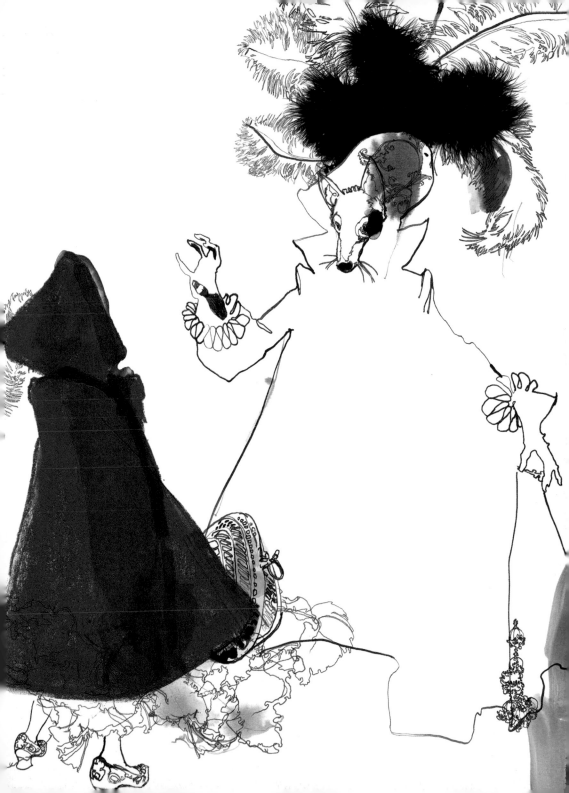

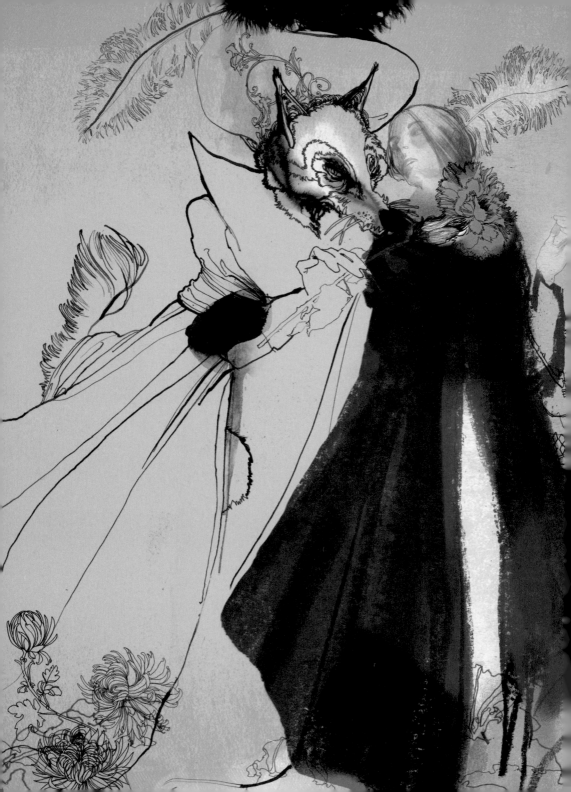

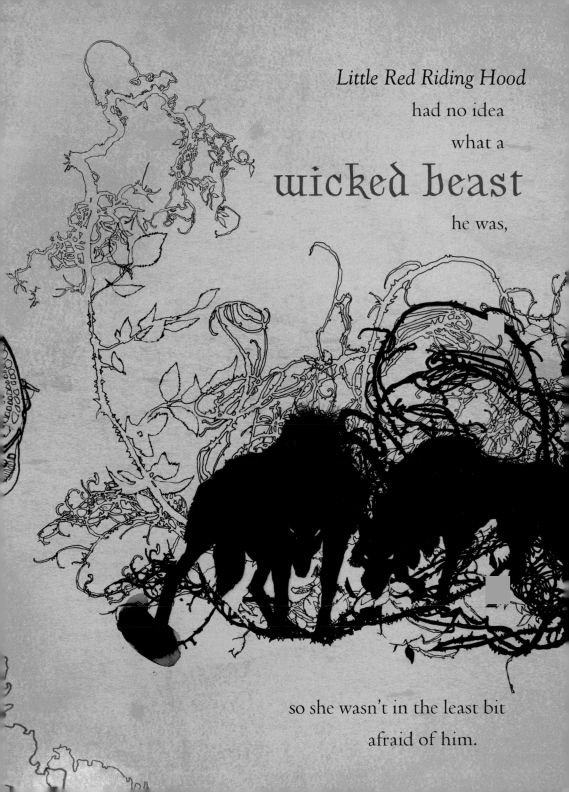

Little Red Riding Hood
had no idea
what a

wicked beast

he was,

so she wasn't in the least bit
afraid of him.

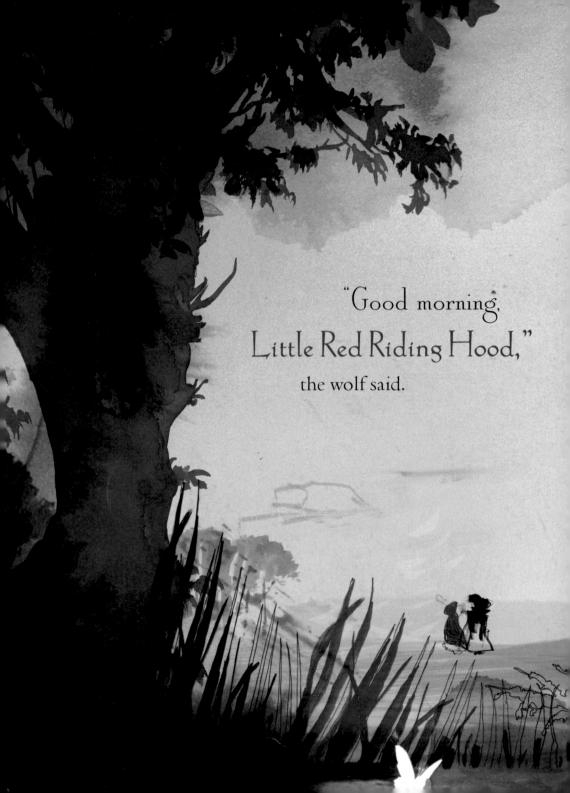

"Good morning,
Little Red Riding Hood,"
the wolf said.

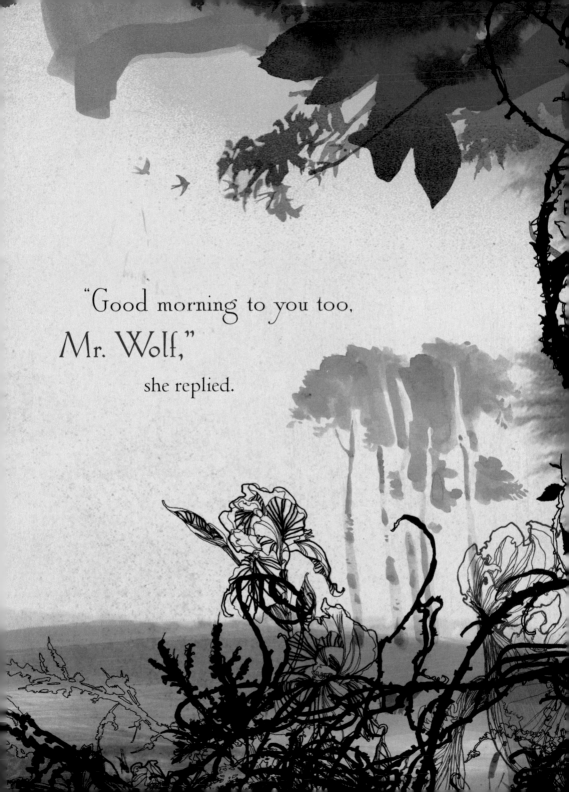

"Good morning to you too,

Mr. Wolf,"

she replied.

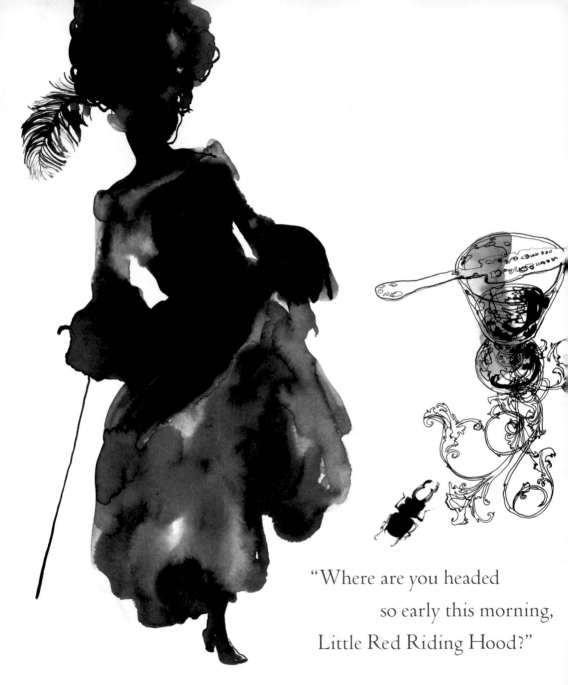

"Where are you headed
so early this morning,
Little Red Riding Hood?"

"TO GRANDMOTHER'S HOUSE,"
she replied.

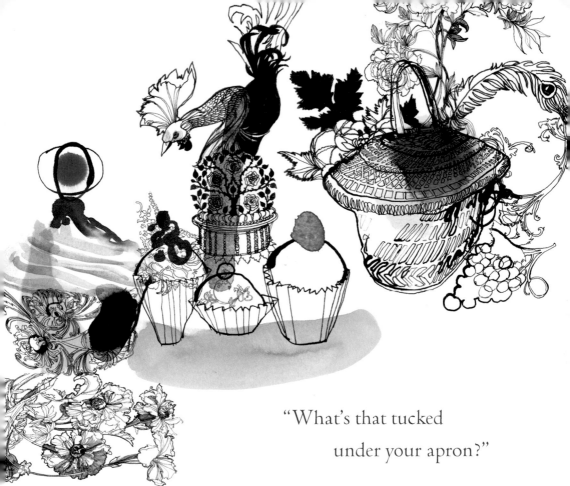

"What's that tucked
under your apron?"

"Some cakes and wine.
Yesterday we did some baking, and

GRANDMOTHER
needs something
to make her *better,*

for she is ill and feeling weak,"
she replied.

"**Where**
is your
GRANDMOTHER'S HOUSE,
Little Red Riding Hood?"

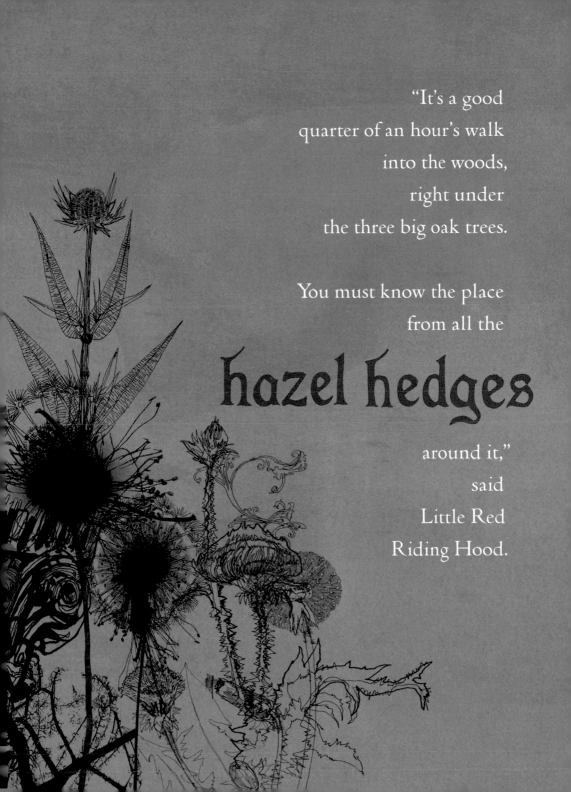

"It's a good
quarter of an hour's walk
into the woods,
right under
the three big oak trees.

You must know the place
from all the

hazel hedges

around it,"
said
Little Red
Riding Hood.

The wolf thought to himself:

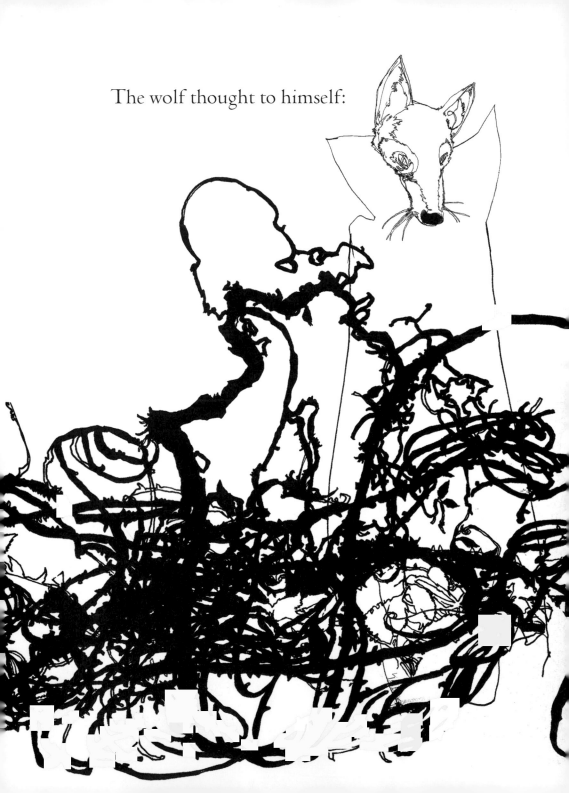

"That *tender* young THING will make a *nice* dainty snack! She'll taste even better than the old woman.

If you're really crafty, you'll get them both." The wolf walked beside *Little Red Riding Hood* for a while. Then he said:

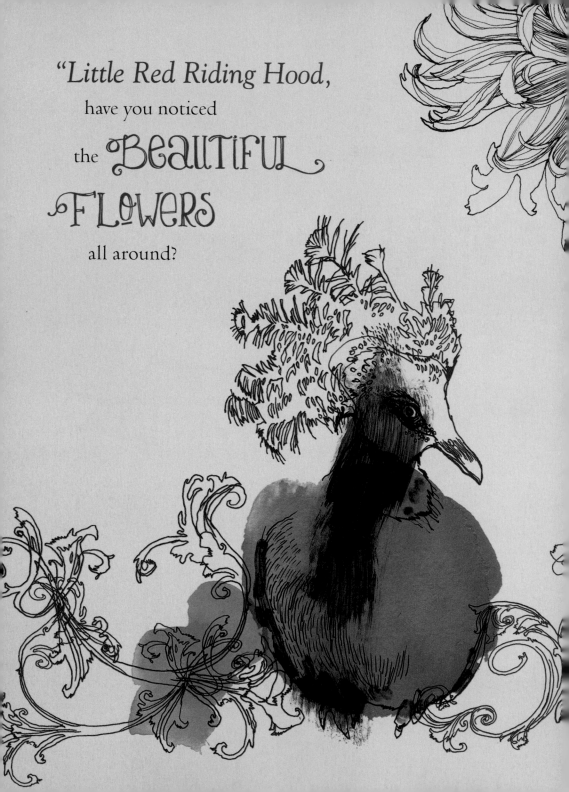

"Little Red Riding Hood,
have you noticed
the BEAUTIFUL
FLOWERS
all around?

Why don't you *stay* and *LOOK*

at them for a while?

I don't think you've even heard
how sweetly the birds are singing.
You act as if you were on the way to school
when it's really so much fun
out here in the woods."

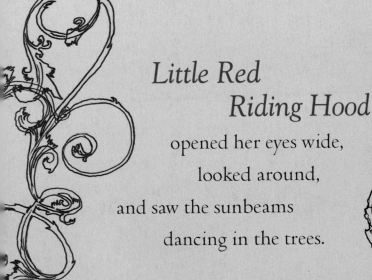

Little Red Riding Hood

opened her eyes wide,
looked around,
and saw the sunbeams
dancing in the trees.

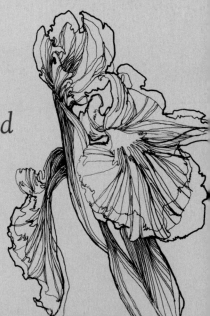

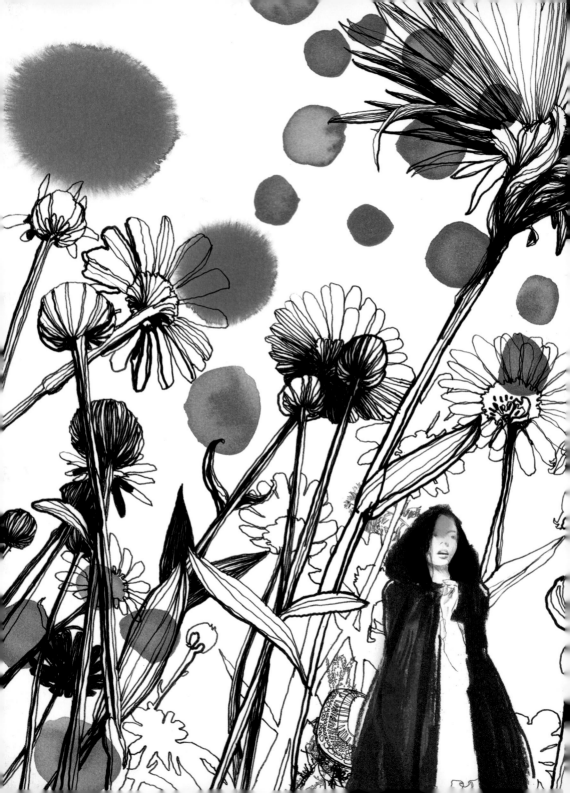

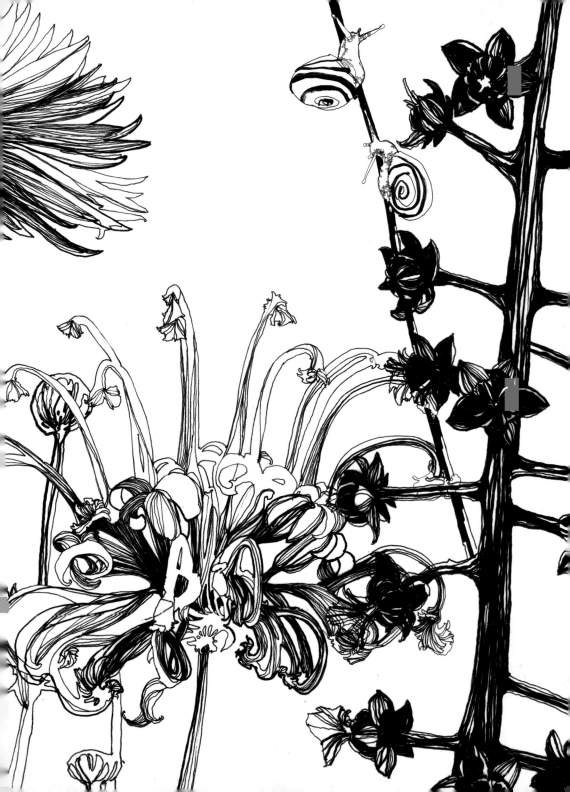

She caught

SIGHT

of the *beautiful*

"If you bring

GRANDMOTHER

a fresh bouquet, she'll be delighted.
It's still early enough that you're sure to get
there in plenty of time."

Little Red Riding Hood

LEFT THE PATH

and ran off into the woods looking for flowers.

As soon as she picked one, she spotted
an even more beautiful one
somewhere else and went after it.

And so she went even deeper
into the woods.

flowers all around and thought:

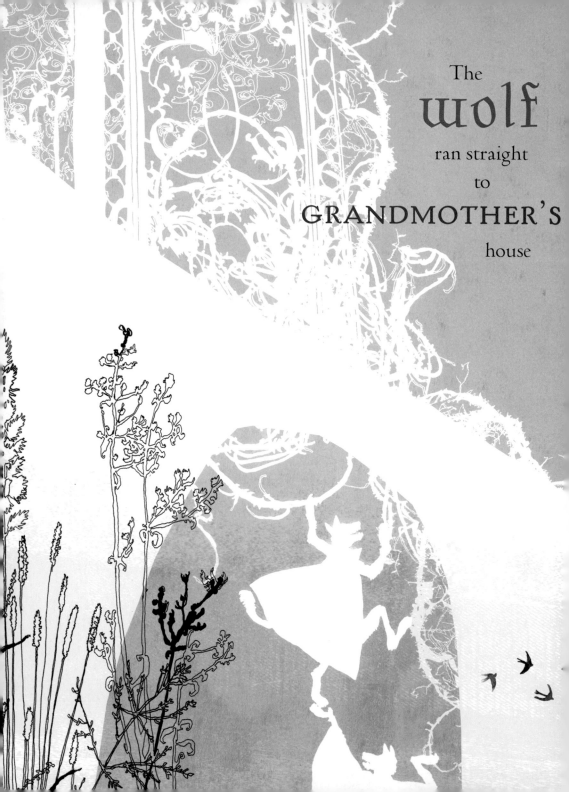

The **wolf** ran straight to GRANDMOTHER'S house

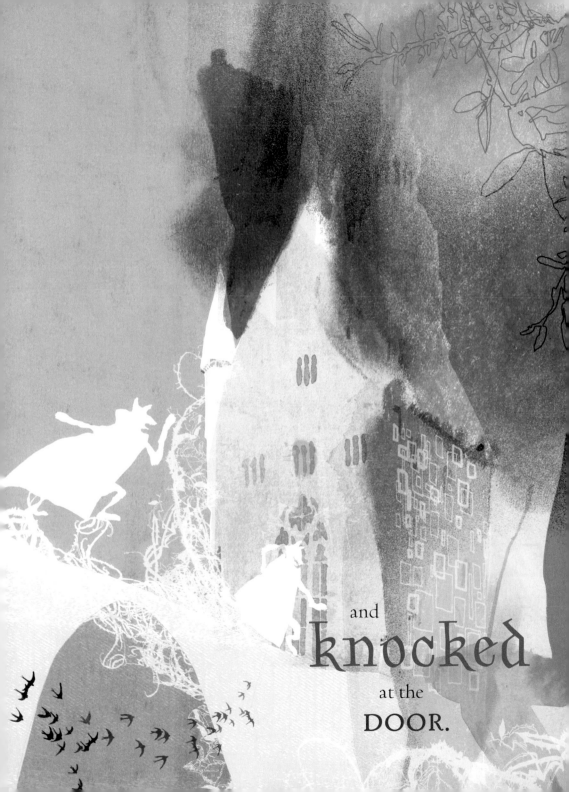

and
knocked
at the
DOOR.

"Who's there?"

"Little Red Riding Hood. I've brought some **cakes** and **WINE.** Open the door."

"*Just raise the latch,*" GRANDMOTHER called out. "*I'm too weak to get out of bed.*"

The wolf raised the latch, and the door swung wide open. Without saying a word, he went straight to Grandmother's bed and **gobbled HER** *right up.*

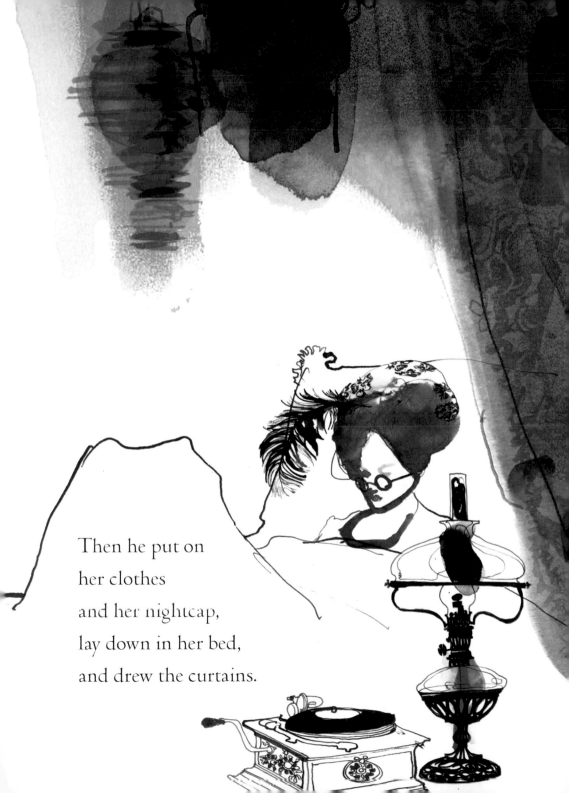

Then he put on
her clothes
and her nightcap,
lay down in her bed,
and drew the curtains.

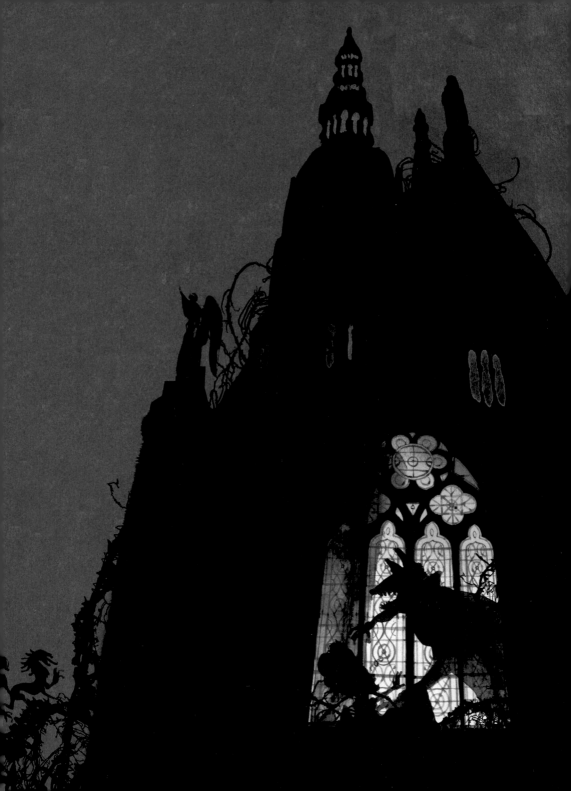

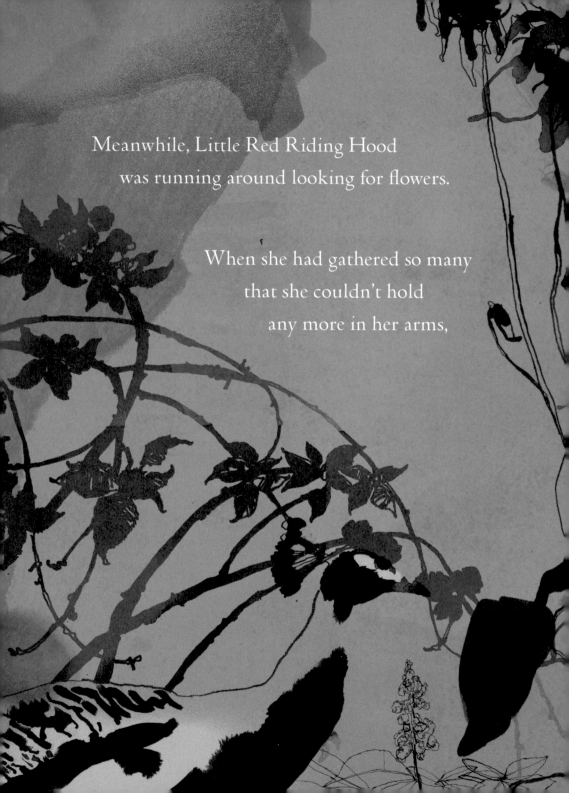

Meanwhile, Little Red Riding Hood
was running around looking for flowers.

When she had gathered so many
that she couldn't hold
any more in her arms,

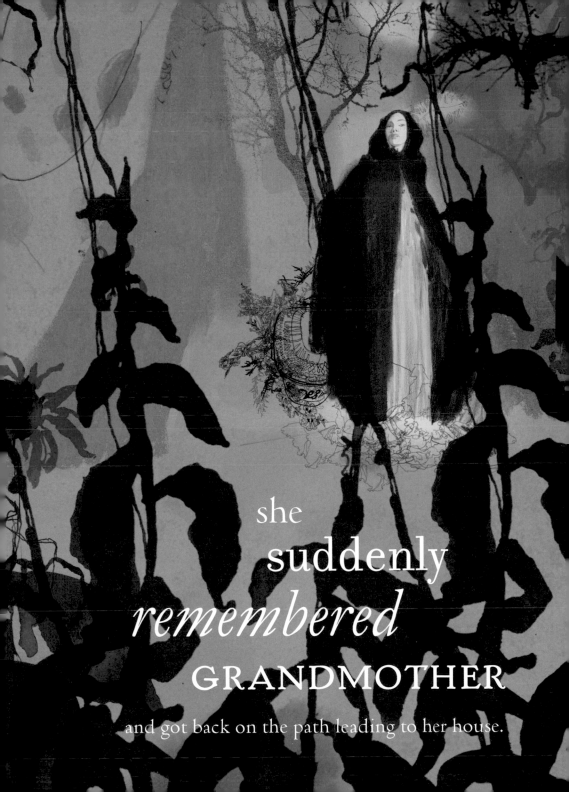

she
suddenly
remembered
GRANDMOTHER
and got back on the path leading to her house.

She was

surprised

to find the gate

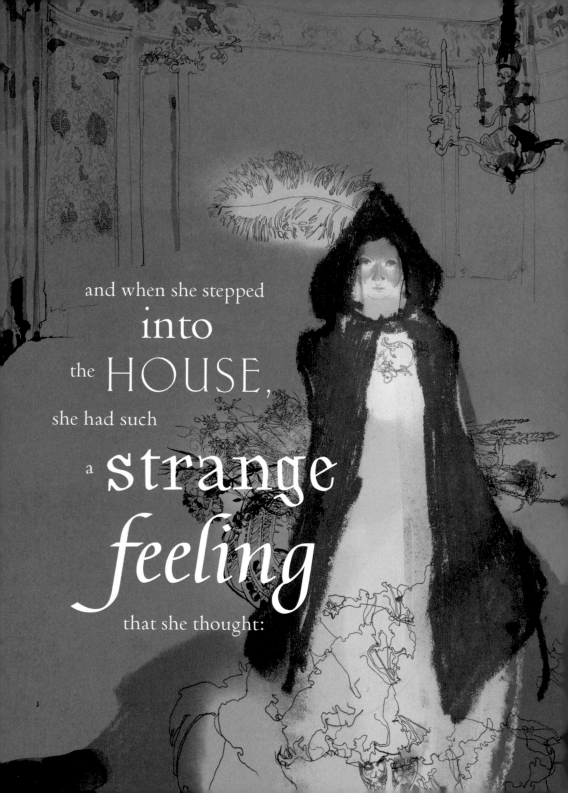

and when she stepped
into
the HOUSE,
she had such

a *strange*
feeling

that she thought:

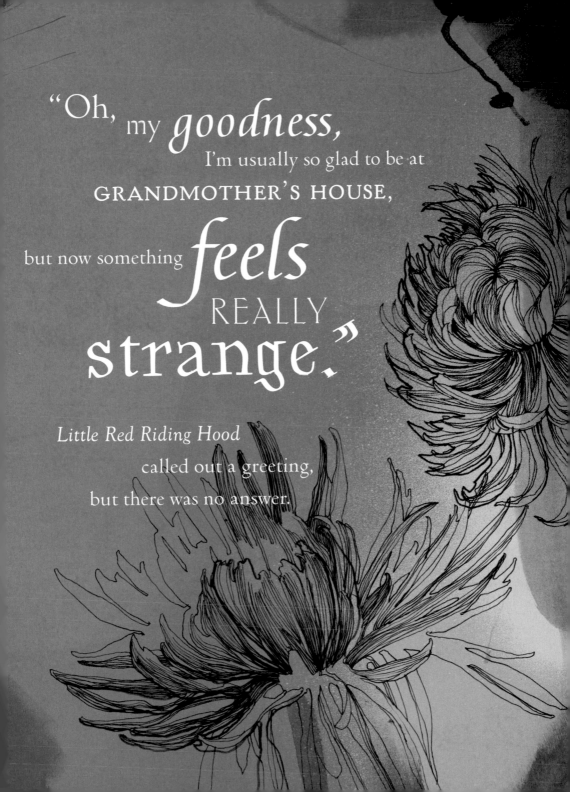

"Oh, my *goodness,* I'm usually so glad to be at GRANDMOTHER'S HOUSE, but now something *feels* REALLY strange."

Little Red Riding Hood called out a greeting, but there was no answer.

Then she went over to the bed
and drew back the curtain.

Grandmother was lying there with her nightcap
pulled down over her face.

She

LOOKED

very

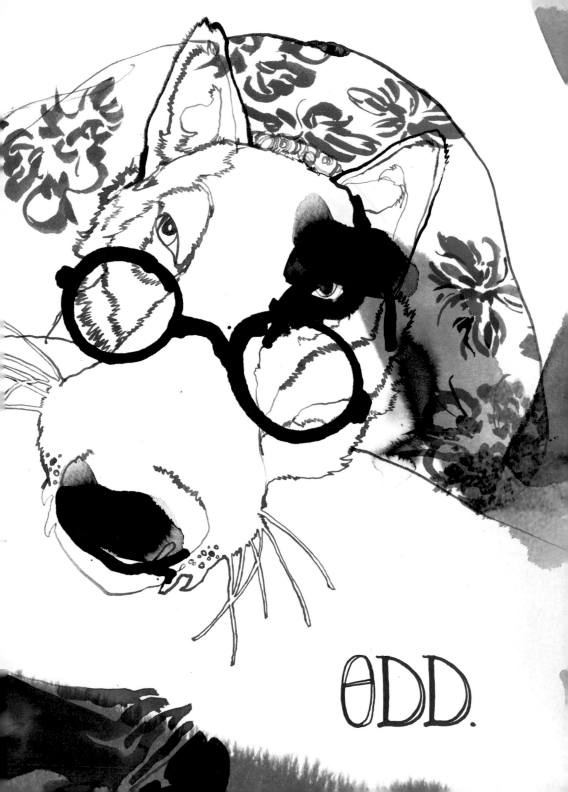

ODD.

"Oh,
GRANDMOTHER,
what big
ears
you have!"

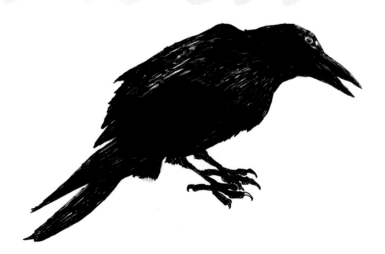

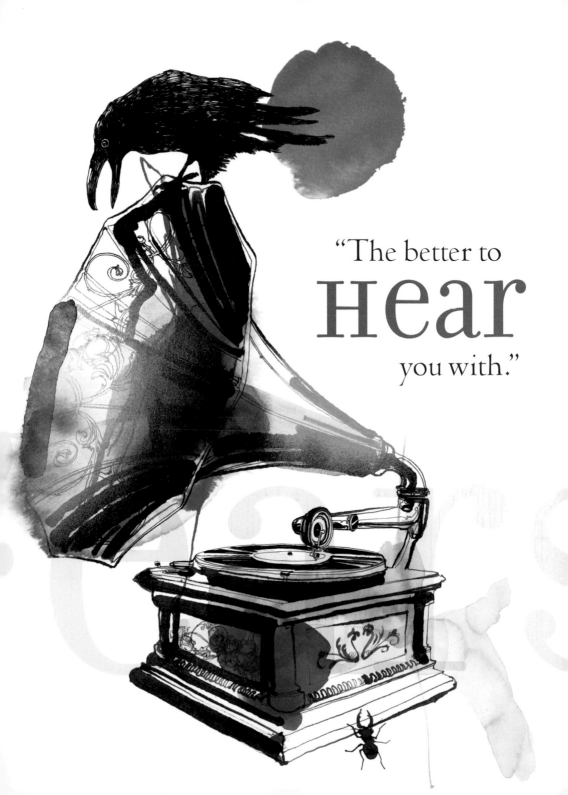

"The better to **Hear** you with."

"Oh,
GRANDMOTHER,
what big eyes
you have!"

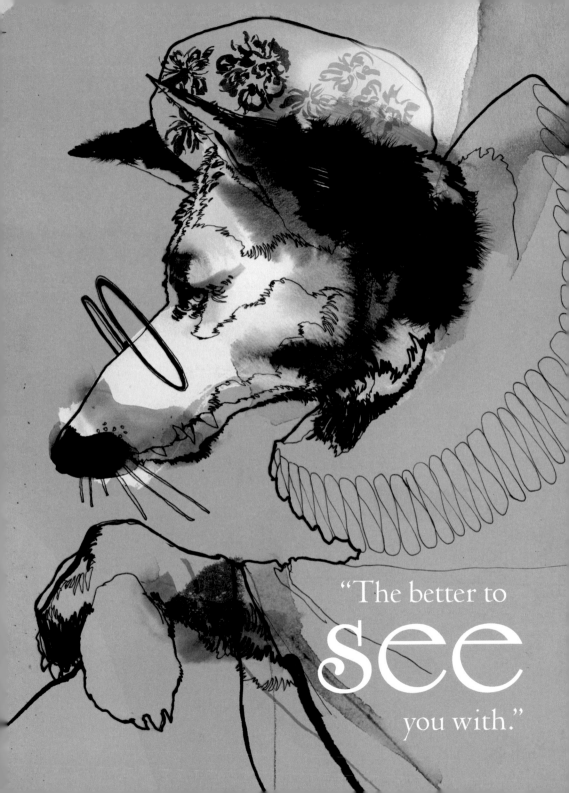

"The better to *see* you with."

"Oh, GRANDMOTHER, *what a big,* scary M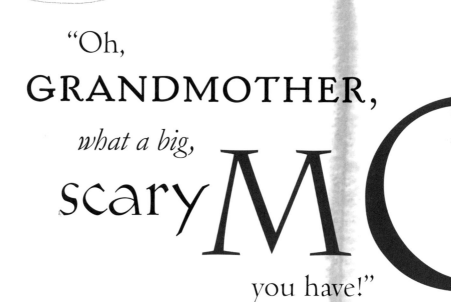 you have!"

"The better to EAT you with!"

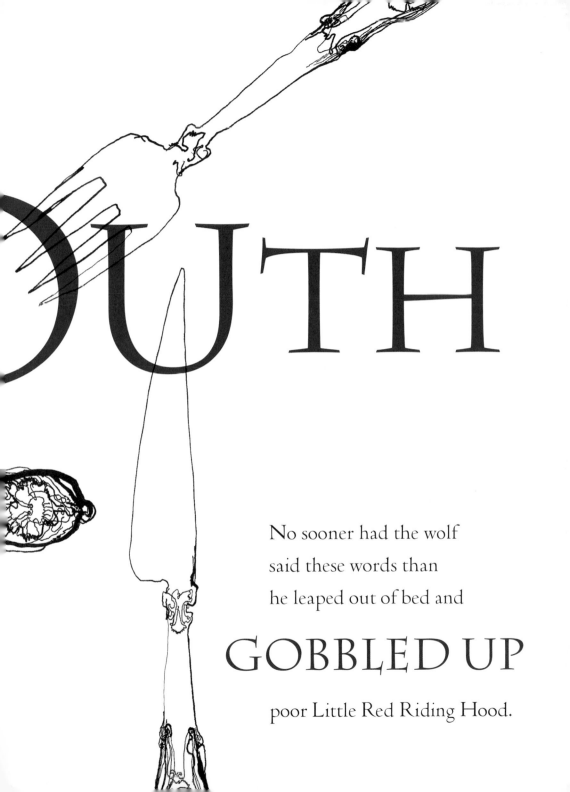

UTH

No sooner had the wolf
said these words than
he leaped out of bed and

GOBBLED UP

poor Little Red Riding Hood.

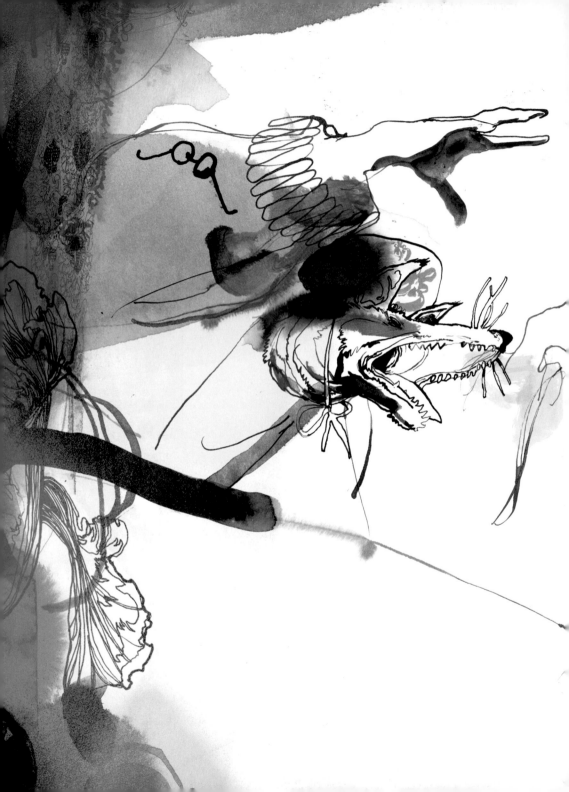

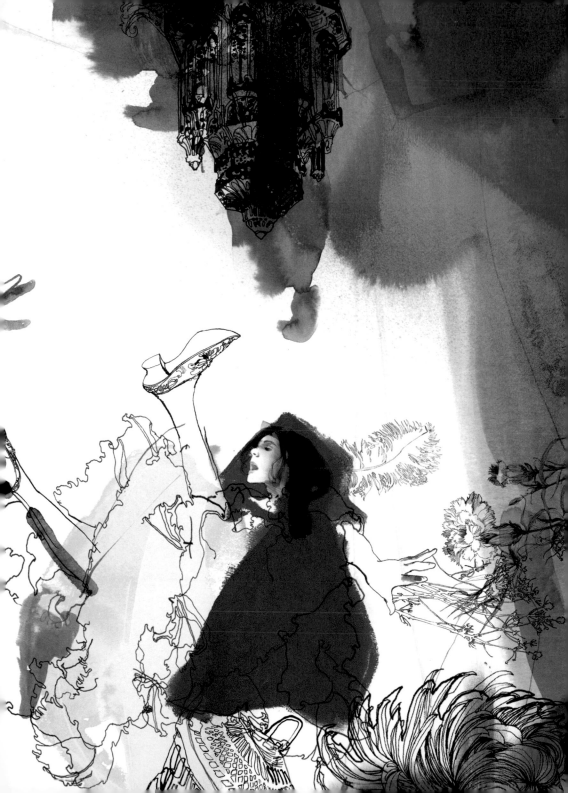

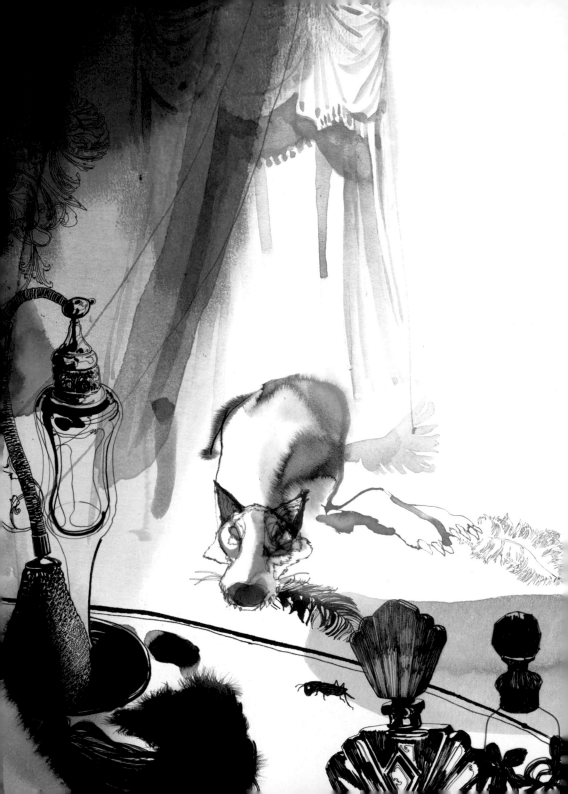

Once the wolf had eaten his fill,

he lay back down in the bed,

fell asleep, and began to snore very loudly.

A HUNTSMAN

happened to be passing by the house just then
and thought:

"How LOUDLY

the old woman is

SNORING!

I'd better check to see
if anything's wrong."

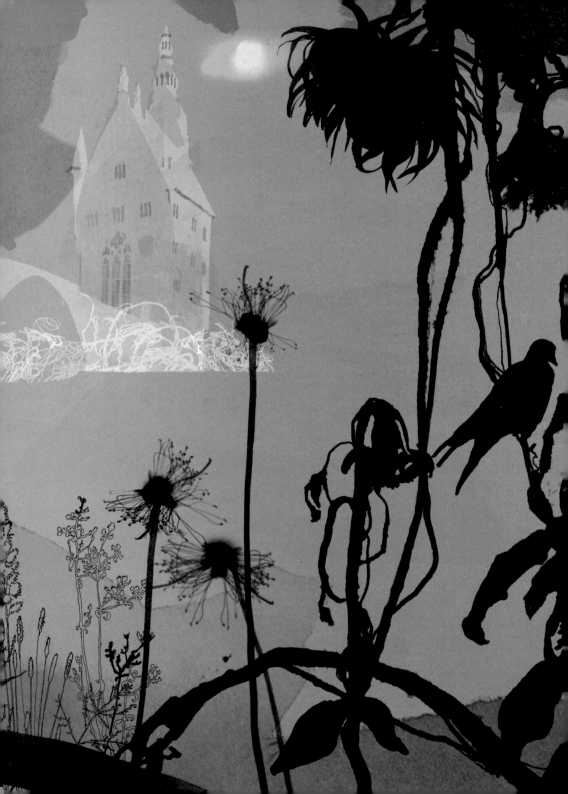

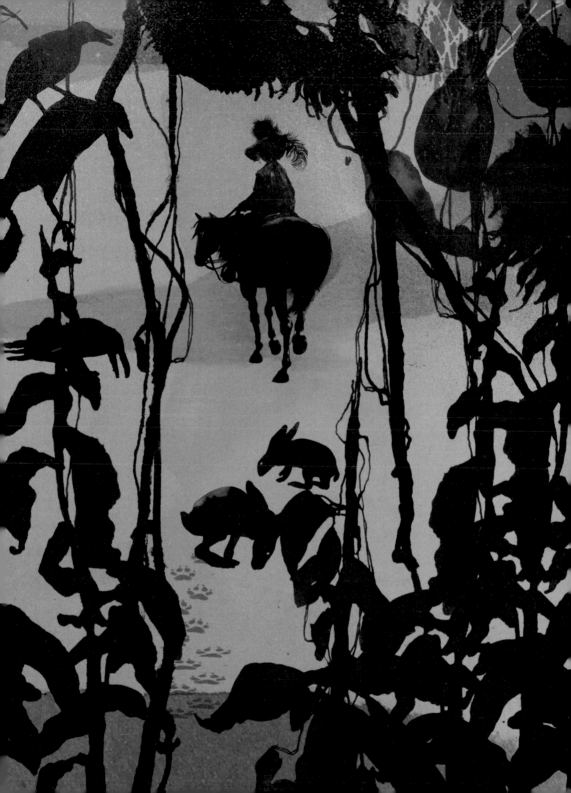

He walked into the house,
and when he reached the bed,
he realized

the WOLF was lying in it.

"I've found YOU at last,
you old sinner,"

he said.
"I've been after you for a long time now."

He pulled out his musket and was about to take aim
when he realized that the WOLF

might have

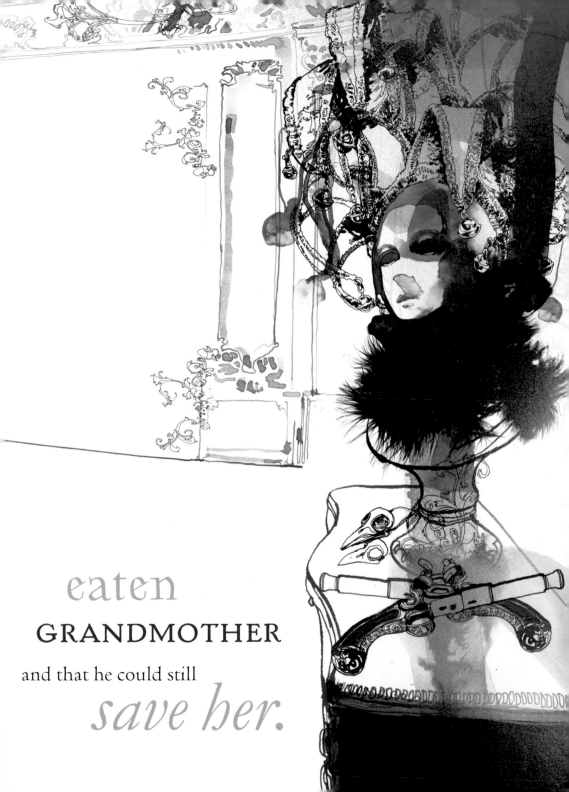

eaten

GRANDMOTHER

and that he could still

save her.

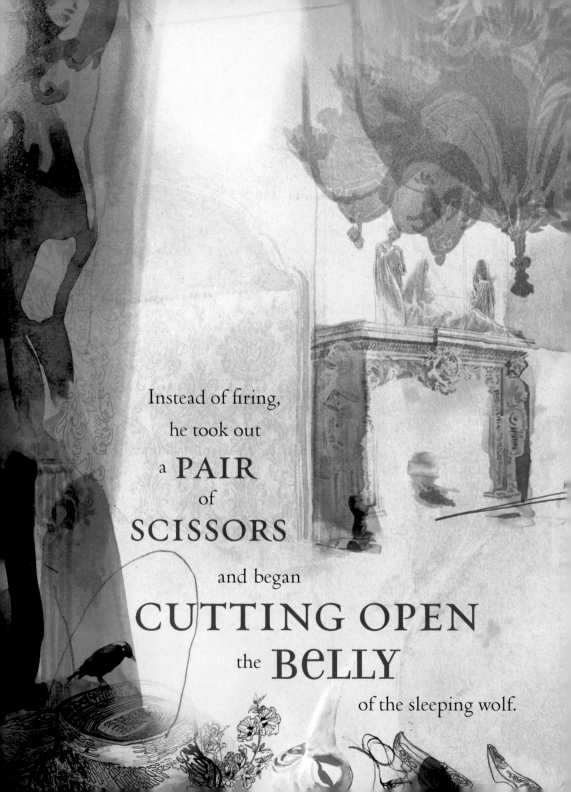

Instead of firing,
he took out
a PAIR
of
SCISSORS
and began
CUTTING OPEN
the BELLY
of the sleeping wolf.

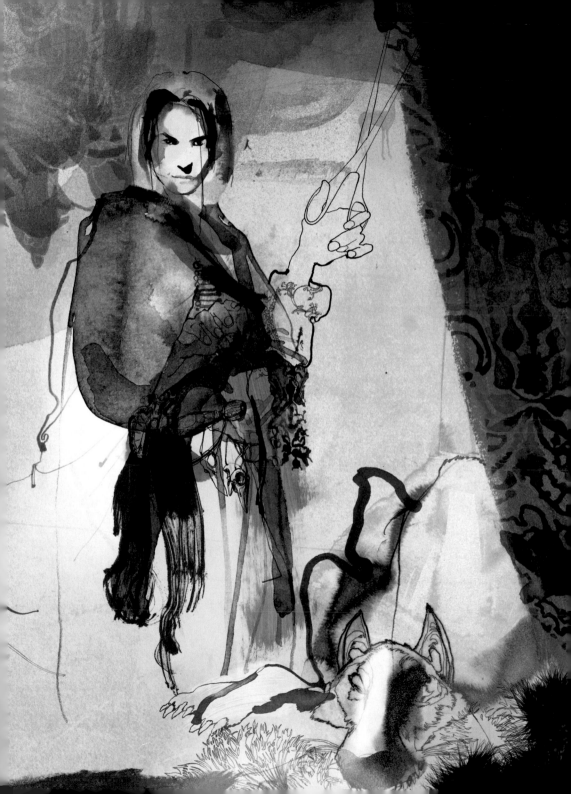

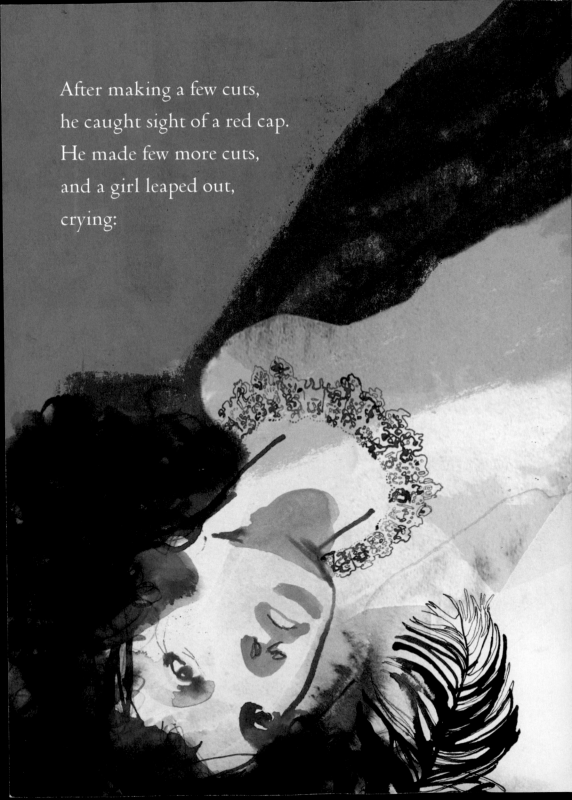

After making a few cuts,
he caught sight of a red cap.
He made few more cuts,
and a girl leaped out,
crying:

"Oh,
I was
so terrified!

It was

so

dark

in the

BELLY

of the

WOLF."

Although she could
barely breathe, the frail
grandmother also found
her way back out of the belly.

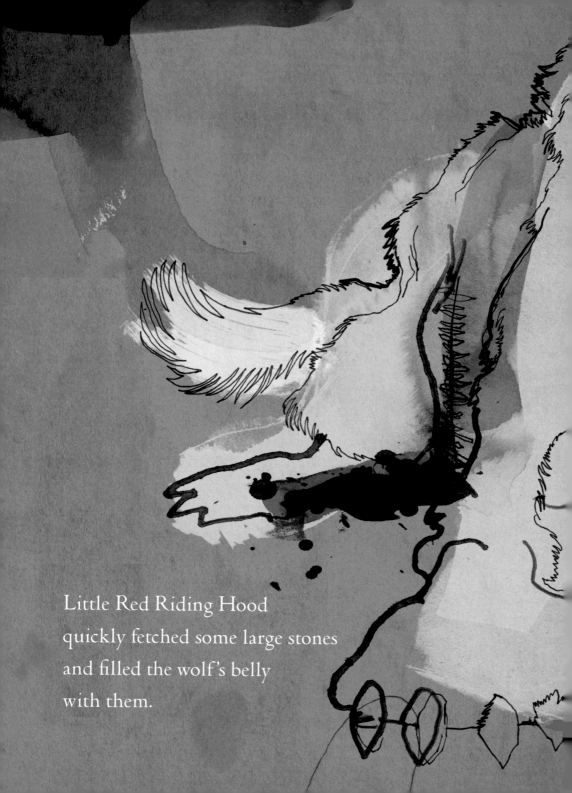

Little Red Riding Hood
quickly fetched some large stones
and filled the wolf's belly
with them.

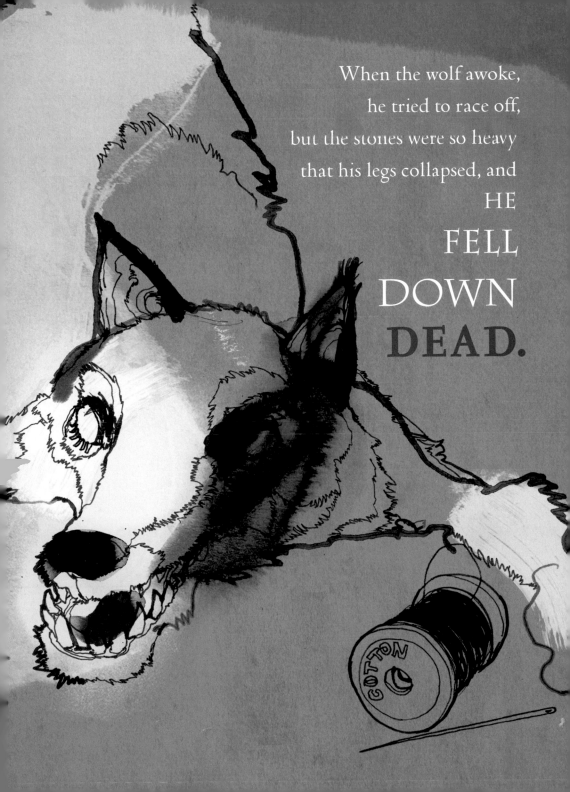

When the wolf awoke,
he tried to race off,
but the stones were so heavy
that his legs collapsed, and
HE

FELL

DOWN

DEAD.

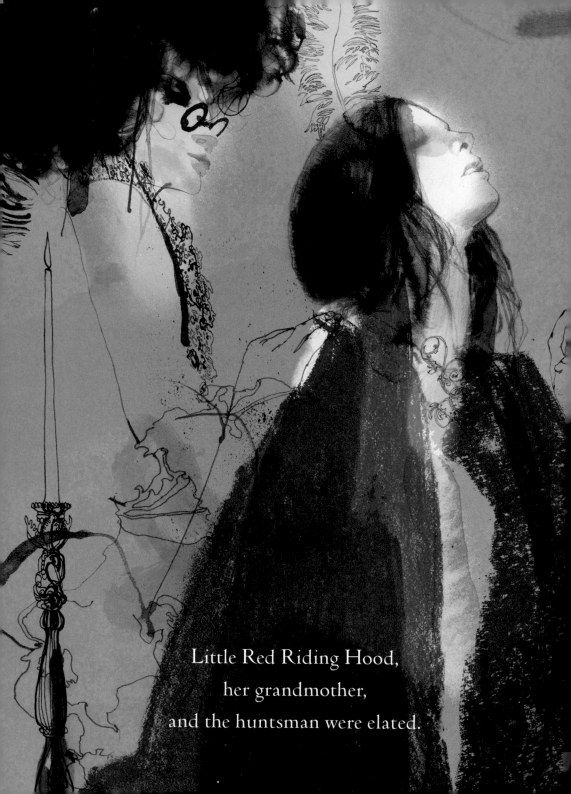

Little Red Riding Hood,
her grandmother,
and the huntsman were elated.

The huntsman skinned the wolf
and took the pelt home with him.

Grandmother ate the cakes and drank
the wine that Little Red Riding Hood
had brought her and recovered her health.

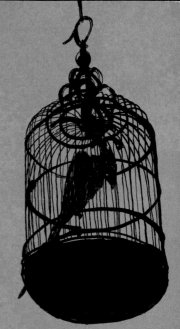

Little Red Riding Hood

said to herself:

"Never again

will you STRAY from the path

and go into the woods

when your mother has forbidden it."

THE END

HarperCollins books may be purchased for educational, business, or sales promotional use.
For information please write: Special Markets Department, HarperCollins*Publishers*,
10 East 53rd Street, New York, NY 10022.

First published in 2011 by
Harper Design
An Imprint of HarperCollins*Publishers*
10 East 53rd Street
New York, NY 10022
Tel: (212) 207-7000
Fax: (212) 207-7654
harperdesign@harpercollins.com

Distributed throughout the world by
HarperCollins*Publishers*
10 East 53rd Street
New York, NY 10022
Fax: (212) 207-7654

Library of Congress Control Number: 2010931501
ISBN: 978-0-06-202051-2

Book design by Iris Shih

Printed in the United States of America
First printing, 2011

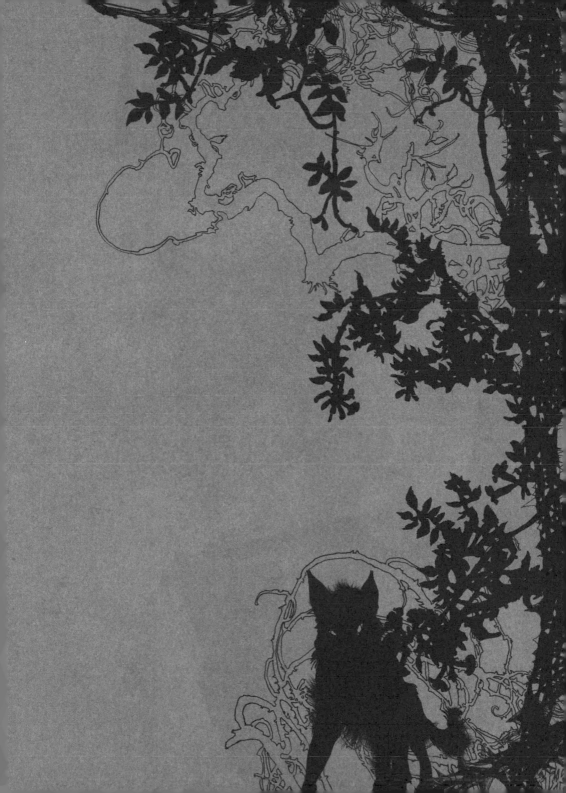

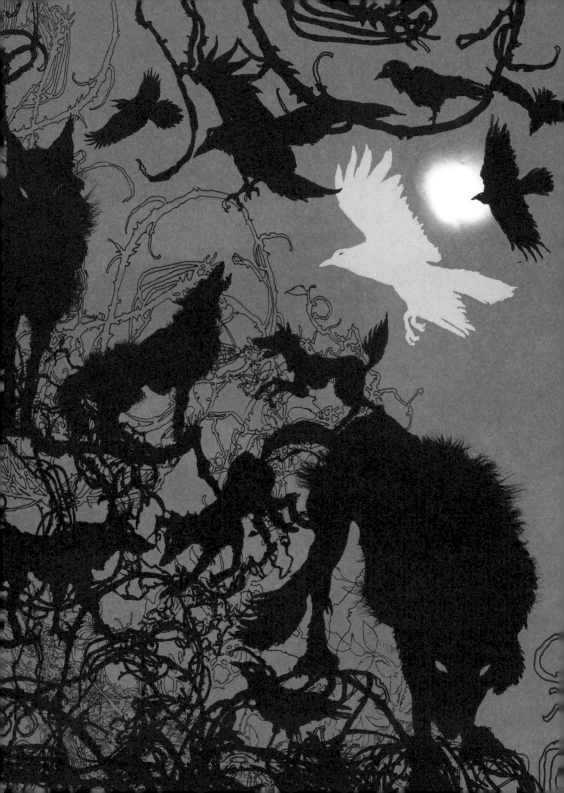